EARTH
KEEPER

EARTH KEEPER

*Reflections on
the American Land*

N. SCOTT MOMADAY

HARPER
An Imprint of HarperCollins*Publishers*

HarperCollins books may be purchased for educational, business, or sales promotional use. For information, please email the Special Markets Department at SPsales@harpercollins.com.

FIRST EDITION

All artwork by N. Scott Momaday

Designed by Elina Cohen

Library of Congress Cataloging-in-Publication Data

Names: Momaday, N. Scott, 1934- author.
Title: Earth Keeper : Reflections on the American Land / N. Scott Momaday.
Description: First edition. | [New York, NY] : HarperCollins Publishers, 2020. | Identifiers: LCCN 2020025782 (print) | LCCN 2020025783 (ebook) | ISBN 9780063009332 (hardcover) | ISBN 9780063009349 (ebook)
Subjects: LCSH: Kiowa literature. | Poetry. | Indians of North America--Folklore.
Classification: LCC PS3563.O47 E278 2020 (print) | LCC PS3563.O47 (ebook) | DDC 814/.54--dc23
LC record available at https://lccn.loc.gov/2020025782
LC ebook record available at https://lccn.loc.gov/2020025783

22 23 24 LSC 10 9 8 7 6 5 4

To the remembered earth

Once in his life a man ought to concentrate his mind upon the remembered earth, I believe. He ought to give himself up to a particular landscape in his experience, to look at it from as many angles as he can, to wonder about it, to dwell upon it. He ought to imagine that he touches it with his hands at every season and listens to the sounds that are made upon it. He ought to imagine the creatures there and all the faintest motions of the wind. He ought to recollect the glare of noon and all the colors of the dawn and dusk.

—from *The Way to Rainy Mountain*

CONTENTS

The reflections contained herein stem from a deep investment in the American landscape. I was born and grew up in the American West. It is a part of the earth that I have come to know well and love deeply. I have been fortunate enough to have traveled over much of the world, and I have experienced many things, met many interesting people, beheld many wonders. I have written about them. But here I have written about what I know best, my native ground. This book is a very personal account, a kind of spiritual autobiography. When I think about my life and the lives of my ancestors I am inevitably led to the conviction that I, and they, *belong* to the American land. This is a declaration of belonging. And it is an offering to the earth.

Many years ago a young woman came to the American West in a covered wagon. I do not know her name, nor do I know the place from which she came. What I do know is this: Among the possessions she brought with her was the one thing she cherished above all others, her wedding dress. It was not the dress in which she had been married, but the dress in which someday she *would* be married. The personal value of such a belonging is of course inestimable. In the folds of the wedding dress were the woman's dreams.

An unknown world opened before her, a landscape so vast and primitive that she could not comprehend it. She beheld distances that seemed endless, a range of form and color beyond her imagination. It was a world

of constant change and profound mystery, incomparable beauty, and, above all, wonder.

I must believe that the woman's dreams were realized, that she wore her wedding dress, and that she became one with the spirit of the land. It is a story of belonging.

ONE

The Dawn

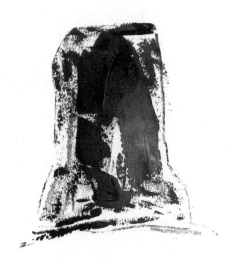

Rock Tree

I am an elder, and I keep the earth. When I was a boy I first became aware of the beautiful world in which I lived. It was a world of rich colors—red canyons and blue mesas, green fields and yellow-ochre sands, silver clouds, and mountains that changed from black to charcoal to purple and iron. It was a world of great distances. The sky was so deep that it had no end, and the air was run through with sparkling light. It was a world in which I was wholly alive. I knew even then that it was mine and that I would keep it forever in my heart. It was essential to my being. I touch pollen to my face. I wave cedar smoke upon my body. I am a Kiowa man. My Kiowa name is *Tsoai-talee*, "Rock Tree Boy." These are the words of *Tsoai-talee*.

Near cornfields I saw a hawk. At first it was nothing but a speck, almost still in the sky. But as I watched, it swung diagonally down until it took shape against a dark ridge, and I could see the sheen of its hackles and the pale underside of its wings. Its motion seemed slow as it leveled off and sailed in a straight line. I caught my breath and waited to see what I thought would be its steep ascent away from the land. But instead it dived down in a blur, a vertical streak like a bolt of lightning, to the ground. It struck down in a creosote bush. After a long moment in which there was a burst of commotion, the great bird beat upward, bearing the limp body of a rabbit in its talons. And it was again a mote that receded into nothing. I had seen a wild performance, I thought, something of the earth that inspired wonder and fear. I hold tight this vision.

The night the old man Dragonfly came to my grandfather's house the moon was full. It rose like a great red planet above the black trees on the crooked creek. Then there came a flood of pewter light on the plain, and I could see the light ebb toward me like water, and I thought of rivers I had never seen, rising like ribbons of rain. And in the morning Dragonfly came from the house, his hair in braids and his face painted. He stood on a little mound of earth and faced east. Then he raised his arms and began to pray. His voice seemed to reach beyond itself, a long way on the land, and he prayed the sun up. The grasses glistened with dew, and a bird sang from the dawn. This happened a long time ago. I was not there. My father was there when he was a boy. He told me of it. And I was there.

On the short-grass prairie where I was born, and where generations of my family were born before me, grasshoppers are innumerable in the summer. In the shimmering waves of August heat they make a dense green and yellow cloud above the red earth. It is slow in motion, and sometimes hesitant, like an ascending swarm, and it is irresistible. You walk along, and you are constantly struck by these bounding creatures. If you catch one and hold it close to your eyes, you see that it appears to be very old, as old as the earth itself, perhaps, and that its tenure is as original as your own.

I dream of Dragonfly, and always in my dreams I am young and he is old. When I see his face it is drawn and wrinkled, the face of a holy man, and there are faint stains of red and yellow paint on his cheeks and about the mouth, made from powdered berries and pollen. His hands have pronounced veins, and the fingers are long and bent from a lifetime of use. He is thin, and his skin is weathered, burned by the sun and wind. His voice too is thin, and his speech is carefully measured. He speaks of things that are the most important to him, spiritual things. He keeps the earth, and he has belonging in my dreams.

There was a tree at Rainy Mountain. It was Dragonfly's tree. Beneath this tree Dragonfly spoke to *Daw-kee*, the Great Mystery. There the holy man was made holy. He was told that every day he must pray not only to witness the sun's appearance, but indeed to raise the sun, to see to it that the sun was borne into the sky, that each day was made by the grace of Dragonfly's words. This was a great responsibility, and Dragonfly carried it well. And at the holy tree he was told of the earth.

We humans must revere the earth, for it is our well-being. Always the earth grants us what we need. If we treat the earth with kindness, it will treat us kindly. If we give our belief to the earth, it will believe in us. There is no better blessing than to be believed in. There are those who believe that the earth is dead. They are deceived. The earth is alive, and it is possessed of spirit. Consider the holy tree. It can be allowed to thirst. It can be cut down. Worst of all, it can be denied our faith in it, our belief. But if we speak to it, if we pray, it will thrive.

When we dance the earth trembles. When our steps fall on the earth we feel the shudder of life beneath us, and the earth feels the beating of our hearts, and we become one with the earth. We shall not sever ourselves from the earth. We must chant our being, and we must dance in time with the rhythms of the earth. We must keep the earth.

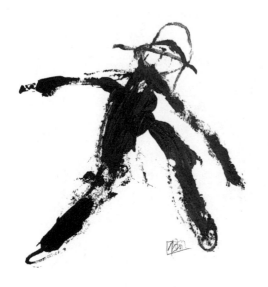

Celebrant

I am an elder, and I keep the earth. I am an elder, and I am a bear. When I was a child I was given a name, and in that name is the medicine of a bear. I speak to the bear in me:

> *Hold hard this infirmity.*
> *It defines you. You are old.*
> *Now fix yourself in summer,*
> *In thickets of ripe berries,*
> *And venture toward the ridge*
> *Where you were born. Await there*
> *The setting sun. Be alive*
> *To that old conflagration*
> *One more time. Mortality*
> *Is your shadow and your shade.*
> *Translate yourself to spirit;*
> *Be present on your journey.*
> *Keep to the trees and waters.*
> *Be the singing of the soil.*

The story from which my name comes is also the story of my seven sisters, who were borne into the sky and became the stars of the Big Dipper. The story is very important, for it relates us to the stars. It is a bridge between the earth and the heavens. There is no earth without the sun and moon. There is no earth without the stars. When we die, Dragonfly says, we go to the farther camps. Death is not the end of life. There is life in the farther camps. The stars are fires in the farther camps.

In the making of my song
There is a crystal wind
And the burnished dark of dusk
There is the memory of elders dancing
In firelight at Two Meadows
Where the reeds whisper
I sing and there is gladness in it
And laughter like the play of spinning leaves
I sing and I am gone from sorrow
To the farther camps

The waters tell of time. Always rivers run upon the earth and quench its thirst. Bright water carries our burdens across long distances. Without water we, and all that we know, would wither and die. We measure time by the flow of water as it passes us by. But in truth it is we who pass through time. Once I traveled on a great river though a canyon. The walls of the canyon were so old as to be timeless. There came a sunlit rain, and a double rainbow arched the river. There was mystery and meaning in my passage. I beheld things that others had beheld thousands of years ago. The earth is a place of wonder and beauty.

Dragonfly speaks of his horse as a hunting horse. Such an animal is greatly prized, he says. There was a time when we had many horses and before that a time when we had none. And we came from darkness into light. The horse is a gift, an offering from the earth. We must live up to the horse; we must be worthy of it. Now my horse is old, and it has but one poor task—to carry me along. But in its blood is the strain of the hunting horse. Old as it is, it dreams of the chase, of its hooves drumming the earth, and it quivers with excitement in the presence of danger. When I see a horse grazing on the skyline it seems a spirit. I think of it ascending to the sun.

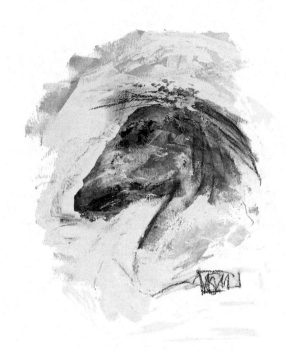

Hunting Horse

That winter was cold and snowy at Walatowa, a good season for hunting. My friend Patricio and I were invigorated by the cold, crisp air as we walked to the river. We approached the river slowly and quietly, but when we drew near, the geese took off in tumult, with a frantic beating of their wings, trailing a great wake of water. It was a thrilling thing to see. Then at once I heard behind me the blast of Patricio's shotgun, and I saw one of the geese struggle and fall. I waded into the river to retrieve it, and I was disturbed to see that it was alive and stricken, but it was perfectly still. Its eyes were very bright, and it seemed to look forever after the pale angle that was dissolving in the dark sky. I cannot forget that look or the sadness that grew up in me. I carried the beautiful creature, heavy and helpless in my arms, until it died. I have lived in the close memory of that day for many years.

We have no-name dogs, Dragonfly says. They have no need of names. We know who they are, and they know who we are. We are in good understanding. There was a time, long ago, when dogs could talk. Think of that. But they were not good with words. They threw them away or used them to make mischief. Before we had horses we had dogs. I am told that when we came from the north, many generations ago, dogs came with us. They dragged our goods and looked after us. They keep the earth.

Dragonfly closes his eyes and pretends to sleep, but the children who sit at his feet know better. They wait patiently. Then Dragonfly opens his eyes and says, *Akeah-de*, "They were camping." He tells of the ancestors who, in the beginning, came one by one into the world through a hollow log. That was a long, long time ago, when dogs could talk. That is a holy place, the place where it happened, Dragonfly says. I would like to see that log. I wonder if it is still there. Probably it has crumbled into the ground. All things are taken back by the earth, for all things belong to it. And all things can be contained in a story.

My ancestors were hunters. For a long time they hunted on foot. It was hard work, and it took most of the hunter's time. He had to stalk his prey, and he had to kill it with a lance or with a bow and arrow. Great skill was required in the hunt, and everyone relied on the hunters for food. It was a question of survival. Then came the horse, and everything changed. Hunting became easier, and new skills and methods were necessary. Much time and effort were saved, and the stature of the hunters was enhanced. The hunters could afford to kill only what was needed. And always the hunters and the people gave thanks for their bounty, and they asked forgiveness from the animals that were killed. There was time to dance and celebrate the earth.

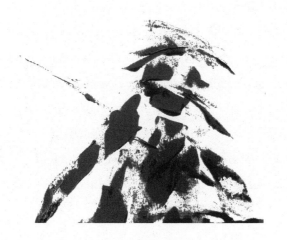

Dance Figure

Dragonfly is a throwback. His view of the world is ancient. It was fashioned in darkness by those who had no language, who were struggling in the agony of birth, the miracle of becoming human. Those ancients were bereft, but there was a spirit within them, and they expressed their spirit by shaping images on the walls of caves. They were in sacred relation with the animals they painted. In their profound art was the construction of a primitive belief, a faith in the essence of the earth. They invented a spiritual life of the mind. Dragonfly is of that mind and spirit. He is a holy man.

Dragonfly holds an eagle feather in his hand. He holds it in such a way that it is horizontal and flat on the air. This belongs to an eagle, he says. And the eagle belongs to the earth and sky. The feather, by itself, may seem a small thing, but the creature of which it is a part is very powerful. That power resides in this feather. It is a power that binds all things together. When I hold this feather, its power flows into me. If I should turn this feather over, you too would turn over. Now I make you a gift of this holy, living feather. You must respect and believe in its power, and now and then you must dip the stem of it in milk, that it may be nourished. And Dragonfly's voice is the voice of prayer.

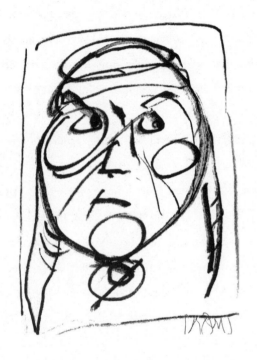

Trickster

Do you see the man in the moon? Dragonfly asks. We are camping, and we can see the full moon. It is large, yellow, and bright, and there is indeed a figure in it. That is Saynday the trickster, grandson. Once the Kiowas were very hungry, and there was no food. Then a scout rode hard into the camp and shouted that he had seen a herd of buffalo close by. Saynday's wife told Saynday that the men were going out the next morning. You must go with them, and you must bring back fresh buffalo meat. Yes, said Saynday. The next day all of the men brought back fresh buffalo meat, but not Saynday. He could find no buffalo, and he brought back tomatoes. His wife beat him with a broom, and he took refuge in the moon. He is afraid to come down. Think of that, grandson. How terrible, to be severed from the earth!

Dusk descends on the late afternoon. A flaming sunset has given way to a darkening old silver sky, and the edges of the landscape soften and barely glow. It is the end of summer, and there is a shiver on the leaves and grasses in the waning light. In the dim distance a coyote moves like the slow shadow of a soaring hawk in the long plain. The earth is at rest.

The force of life is very great, Dragonfly says. Some years ago the prayer tree at Rainy Mountain was struck by lightning. It burned and turned black, but it did not fall. There had not been time to speak of the tree to *Man-ka-ih*, the storm spirit. The tree seemed to be dead. But a long time afterward there appeared a tiny sprig of green on a charred limb, and then the hidden life of the tree burst out in a hundred leaves. It was a wondrous sight, and I wept to see it. I believe that the earth gave of its irresistible life to the tree. How can we not give thanks in return?

You must taste the earth, Dragonfly says. It is good for you. The earth gives us many things that strengthen and heal us. Even the bare ground upon which we walk is good for our well-being. Observe the mole that is so much at home underground. When it is building its house, it comes again and again to the surface and blows a fine spray of dirt all around. This powdered earth can be tasted or inhaled to our benefit. The turtle too is a creature that knows of the deep earth. And when we see it go to high ground, we follow it, for it knows when a flood is coming. It is good to look into the face of a turtle, for there we see great age and wisdom. And see how it goes indefinitely on its crooked legs.

And often one heard from the old people, those like Dragonfly, who were elders before my time. Once, according to the old woman *Smoke*, there was a Sun Dance on Oak Creek. There were many visitors, and the camps were made clean and beautiful. Fresh, sandy earth was brought from a distance and placed in the Sun Dance lodge. The dancers, praying for good things in the coming year, danced on the sand, tamping it into the older earth, enriching it. That year the hunting was good, and the visitors brought many gifts. The calendars record a time of plenty.

I stand where Dragonfly stood and prayed; *Daw-kee*, give light and life to your people. Give us one more day, and one more, and at last one more. I lift my old arms in bold entreaty. There the house and arbor are falling into ruin. Those who have inherited the homestead have not cared for it. Inside the arbor, once a place of happy activity and joyful talk and laughter, I place my bare feet on the red earthen floor and breathe the summer-scented breezes that enter there, I bless this place which is sacred to me, and I ponder the omen of the dead white owl that I found in the gutted house. Even in death the snowy creature is a keeper of the earth.

May my heart hold the earth all the days of my life. And when I am gone to the farther camps, may my name sound on the green hills, and may the cedar smoke that I have breathed drift on the canyon walls and among the branches of living trees. May birds of many colors encircle the soil where my steps have been placed, and may the deer, the lion, and the bear of the mountains be touched by the blessings that have touched me. May I chant the praises of the wild land, and may my spirit range on the wind forever.

The Dusk

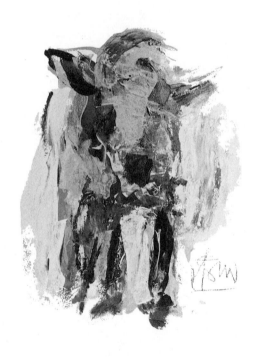

Buffalo Calf

When the great herds of buffalo drifted like a vast tide of rainwater over the green plains, it was a wonderful thing to see. But there came a day when the land was strewn with the flayed and rotting remains of those innumerable animals, slain for sport or for nothing but their hides. The Kiowas grieved and went hungry, and it was the human spirit that hungered most. It was a time of profound shame, and the worst thing of all was that the killers knew no shame. They moved on, careless, having left a deep wound on the earth. We were ashamed, but the earth does not want shame. It wants love.

Something of our relationship to the earth is determined by the particular place we stand at a given time. If you stand still long enough to observe carefully the things around you, you will find beauty, and you will know wonder. If you see a leaf carried along on the flow of a river, you might ponder its journey. Where did it begin, and where will it end? What will be the story of its passage? You will discover a thousand ways in which the leaf is connected to the water, the banks, the near and farther distances, the sky and the sun. Your mind, your spirit will be nourished and grow. You will become one with what you see. Consider what is to be seen.

There was a remarkable thing beside the highway, a billboard without words. It was a painting, a large and precise replica of the landscape behind it. On the picture plane you saw what you would have seen had it not been there, not the likeness, the reality. I began to think about it. It was a conversation piece, a clever hoax, but a hoax nonetheless. It was, if you will, a sign of the times. How many lifeless things are placed each day between us and the living earth? A friend in Brooklyn told me that his little son had gone out to watch workmen breaking up a sidewalk. He was fascinated to see earth under the cement. He had never seen it before.

There is no love without loss. I hear the drums that vibrate to the heartbeat of the earth. They set me dancing. I see the clouds that wreathe the summits. They set me dreaming. I know the wonder of waves that shake the headlands. They awaken my soul. I hear the screams of eagles on the wind. And I ponder, what are these things to me who loves and does not reckon loss? Do I not keep the earth? Those who came before me did not take for granted the world in which they lived. They blessed the air with smoke and pollen. They touched the ground, the trees, the stones with respect and reverence. I believe that they imagined me before I was born, that they prepared the way for me, that they placed their faith and hope in me and in the generations that followed and will follow them. Will I give my children an inheritance of the earth? Or will I give them less than I was given?

In my dream the holy man Dragonfly speaks of the woman who was buried in a beautiful dress. She is somewhere out there in the land. She has gone to the farther camps, but her bones are at home in the dress, in the earth. Once she had a name, but it is forgotten. Once it was known where she is buried, but now no one knows. Once she was a girl who laughed and danced and listened to the stories of her ancestors. But now she is the woman who was buried in a beautiful dress. There is mystery and meaning in that. The earth has taken her in. She has being in the earth. This is a story of which you dream, grandson. The earth is a house of stories. *Akeah-de*.

When I was a boy my father took me to a place where relatives once lived. Nothing was left of the house but traces of a foundation. The place was far out on the plain, so far that mountains were in sight. My father, when he was a boy, visited the people there. At night, he said, we could hear the howls of prairie wolves. They are gone now. I would like to have seen them. Your grandfather told me that they were handsome, with long legs and beautiful yellow eyes, wild and searching. I try to see the wolves in my mind's eye, but I can only imagine them. I wish I could describe them to you. My father's voice had trailed off. Will I tell my grandchildren, I wonder, of animals they will never see?

The earth is not impervious to the presence of man. We humans have inflicted terrible wounds upon the earth. The scars are everywhere visible, even here where Dragonfly brought up the sun and where I was given my sacred name. The arbor is now a ruin, for it came into the hands of uncaring and visionless people. Inside is the evidence of life once having been. There my grandmother sat with her beadwork, and there my father set his initials in Gothic characters on the wall when he was a boy dreaming of becoming an artist. There were prayer meetings here in the night, and hymns sung in Kiowa. The voices carried on the prairie darkness to Rainy Mountain Creek and beyond. In my memory I can hear them. I touch the red earthen floor. It is beyond the indifference which has crumbled these walls. It will be here after all. After all it will be here.

On one side of time there are herds of buffalo and antelope. Redbud trees and chokecherries splash color on the plain. The waters are clear, and there is a glitter on the early morning grass. You breathe in the fresh fragrances of rain and wind on which are borne silence and serenity. It is good to be alive in this world. But on the immediate side there is the exhaust of countless machines, toxic and unavoidable. The planet is warming, and the northern ice is melting. Fires and floods wreak irresistible havoc. The forests are diminished and waste piles upon us. Thousands of species have been destroyed. Our own is at imminent risk. The earth and its inhabitants are in crisis, and at the center it is a moral crisis. Man stands to repudiate his humanity.

In winter on the northern prairie I came upon a scene of ineffable beauty. There were vast sloping snowfields, and everywhere there were shrubs crusted with ice. In the January light they shone with a crystalline brilliance that glittered like shards broken from the sun. On a blue-white hillside there appeared a bull elk moving diagonally down to a dense wood and out of sight. The elk and the wilderness belonged to each other, I thought, and in the spectrum of evolution I was estranged from both. The next morning I heard the whine of chainsaws in the distance.

At the pueblo of Walatowa I came to know a world that was remote in time and space. I was twelve years old when my parents and I moved there. In my day the life of the town had remained by and large unchanged for hundreds of years. The people grew corn and melons and chili; they hunted deer and bear in the mountains, and they captured golden eagles for use in their ceremonies. Time was told on a solar calendar, according to the position of the sun on the horizon. There were ceremonial dances and feast days of marked activity and color. I fitted myself into the ancient rhythm of life there and came to know that country far and wide on the back of a horse. Then that world began to change with the return of young men from World War II. Many of them had been psychologically severed from the traditional earth. It was a time of loss.

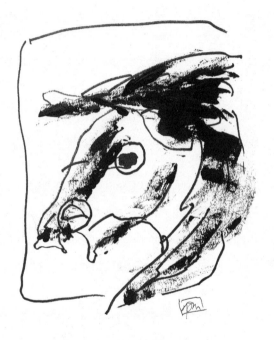

War Pony

On my way to school I passed by the sheep corral of Francisco Tosa, an old man of Walatowa who was preparing to herd his flock out to graze. He always greeted me with a shout, "*Muy bonita día!*" And he laughed under his big straw hat. It was impossible to say how old he was. The skin on his face and hands was greatly weathered, and he walked at a slow pace. But there was a sharp vitality in him, and a generosity of spirit that seemed boundless. The sheep were his children, I believe, and he loved them unconditionally. I have come to think of him as a singular and worthy man, one with whom God would play hide-and-seek. Francisco lived closer to the earth than most men do, and I am exceedingly fortunate to have crossed his path. It might have been he who, in the purity and grace of his simple soul, brought rainbows to the canyon walls.

Several years ago, on the bank of a river, I witnessed a total eclipse of the sun. That was a strange thing. For a profound moment there was night in the afternoon. Shadows rippled on the sand, and the world was deceived. Thousands of years ago someone, a cave dweller, perhaps, who was emerging into language and thought, observed the same phenomenon. What did it mean to that primitive mind? Was there fear, confusion, acceptance? Was the moment given a sign, a name? The temporal distance between that ancestor and me is inconceivable, and yet the map of human history is etched there. And it is concentrated in a single transitory moment of darkness in which the earth, the moon, and the sun are in perfect alignment.

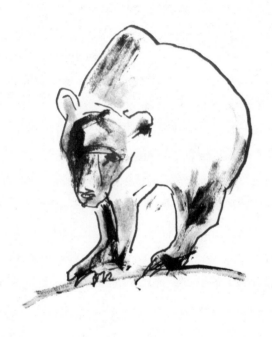

Sentry

I met a man of the mountains, a singer of prayers and a hunter. When he killed a wild animal, it was done for food, and he always asked its forgiveness and anointed it with pollen. Bears, especially, were his friends. He was known by one name only, *Stone*. Over the years he became my spiritual brother, and we exchanged tributes in song and prayer. He was a man of great goodwill and wisdom, and he was an earth keeper. Our songs were informed by our respective oral traditions and a reverence for nature. He lived on land that was rich in timber and game, and he was literally losing ground to the encroachment of poachers and speculators. In time he lost something of his spirit, and he went down a solemn way. And when I received notice of his death, I drew the image of a bear and named it *Stone*.

A teacher once said to me, write little and write well. He was a poet and a man who took literature seriously. He wrote this: "Unless we understand the history that produced us, we are determined by that history. We may be determined in any event, but the understanding gives us a chance." What is the critical force of that understanding, I wonder? Are we to witness the eclipse of our civilization? Or are we to take the chance? The teacher raised Airedales for show and tended an orchard in his backyard. Had he not taken literature seriously, he told me, he would have been a farmer.

I rode on horseback to the west, to the red labyrinth. There were hawks overhead turning narrowly down, then soaring up and far away, and in their own time returning. All afternoon they regarded me. Then, when the shadows grew long I entered the labyrinth, and the cliffs leaned over me. From the darkness within, a gust of cold wind came loud and bolting, and I was nearly thrown to the ground. It was not the wind of the plain, but something of the labyrinth itself, essential and deep, without definition or a name. I rode out into the cauldron of the late light and searched the sky for the hawks, but they were no longer there. I felt that I had been to the center of the earth, to the house of Genesis.

How are we to ward off the immorality of ignorance and greed, the disease of indifference to the earth? Perhaps the answer lies in the expression of the spirit, in words of a sacred nature. The efficacy of Dragonfly's prayer to the sun is realized in the miracle of dawn. We must not doubt that it is so.

> *Great Mystery, give us one more day, and one more, and then one more. I lift my arms in bold entreaty.*

And when *Stone* touches pollen to the head of the bear he utters words that affirm the kinship of the hunter and the hunted, the communion of life and death, the beneficence of the earth.

> *I make a prayer for words. Let me say my heart.*

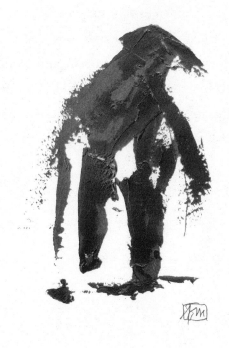

Bear Man

I offer a blessing of water. You, like grasses in the afternoon, when they feather and ripple out in arcs of wind, turn and return, your whole being of a piece, singular in form and grace. You are the slow, supple motion of clouds drifting, of purling air over September meadows. Toward my village you walk. I regard you. You come, appearing in dappled light on the rolling land. When you reach the spring I will have drawn water for you. Look for me, and in the manner of an earth keeper I will be there.

A friend and colleague of mine wrote of the Machine in the Garden and another wrote of the Virgin Land. These writings center on the coming of the Industrial Age to a pastoral America and the notion of Manifest Destiny, respectively. Both are important studies of American history, and as such they focus upon the past. But it is the present and the possibilities of a future that must concern us. Ours is a damaged world. We humans have done the damage, and we must be held to account. We have suffered a poverty of the imagination, a loss of innocence. There was a time when "man must have held his breath in the presence of this continent," this New World, "commensurate to his capacity for wonder." I would strive with all my strength to give that sense of wonder to those who will come after me.

At night I listen to the dogs of the village and the coyotes of the wilds. They convene at the river and exchange their opinions on important matters of mutual concern. There is much banter and boasting. The dogs are well known to me, but the coyotes are mysterious. To one who listens on a cold night to those otherworldly voices, they seem to ascend into space and to chip at the tooth of the moon. Night describes the edge of sound until first light appears, and on the fringe of hearing the strange music ebbs into the void and is no more. And then the circumference of silence encloses the dawn.

Those who deny the spirit of the earth, who do not see that the earth is alive and sacred, who poison the earth and inflict wounds upon it have no shame and are without the basic virtues of humanity. And they bring ridicule upon themselves.

I am ashamed before the earth
I am ashamed before the heavens
I am ashamed before the dawn
I am ashamed before the evening light
I am ashamed before the sky
I am ashamed before the sun

This pronouncement from the Navajo has increasing relevance in our time. *Daw-kee*, let me not be ashamed before the earth.

One summer day I sat outside at a table on which I drew in a sketchbook. By the table grew a broad-leafed plant. It was exactly as high as the tabletop, and it was only inches away from me. As I worked, a butterfly alighted on the nearest leaf. It amazed me, for it was the largest and most beautiful butterfly that I have ever seen, nearly the size of my two hands cupped together, and a deep iridescent blue, like the cobalt blue of a sky in which a storm is building. It struck me with wonder, and a kind of humility, and I could look at nothing else. Then it flew away. And I was sad to see it go. But a strange feeling came over me, and I said to myself, with a knowing that I cannot explain, that it would return. And so it did. I believe that the beautiful creature and I had entered into a kind of mystical communion, accepted but not understood.

My plane landed at Coppermine to take on fuel. I was coming from Holman Island on my way to Yellowknife, and it was the middle of the night. The ground time was short, but I felt the need to stretch my legs, and I stepped outside. Suddenly my breath caught in my throat. The Northern Lights were squarely upon me. The shock of that magnificent show was greater than that of the icy wind. Great ribbons of dancing light unraveled on the snowy sky, and a great shiver of color enveloped the dome of the earth. It was an event of profound spiritual moment, such as a child knows in the splendor of a Christmas tree, and there was in my soul a song of celebration.

Gathering

It is in human nature to pray. It is appropriate that we lay our words upon the earth. And so: Great Mystery, you who dwell in the endless beyond, you who spoke the first word and made of your breath the mountains and the waters, the trees and the grasses, the man and the woman and the child, hear me in my small voice. I am your thankful creature. My people and all the birds and animals are your thankful creatures. Hold us! Hold us in your hands, and make us worthy of your blessing. Tell us the old stories of your greatness, that our minds and our hearts may be nourished with wonder and delight. Let us see your likeness in the stars, and let us hear your voice in rolling thunder and in the wind and rain. Be with us forever in the sacred smoke of your being. These are my words, my offering to you, Great Mystery.

A friend and kinsman, Botone, raised horses in Colorado. One day he came to visit me in Tucson, where I was then teaching at the University of Arizona. He told me the story of a man who in battle turned his horse from a charge into the enemy. The horse died of shame. Botone wept in the telling, and I realized the depth of his feeling. Before he left he placed in my hand a stick about the size of a crayon. This stands for a horse, he said. It is traditional. And a few days later there arrived at my home a beautiful Appaloosa mare, and I was reminded of the mythic bond between man and horse in the Plains culture, also known as the centaur culture. I have twice been made the gift of a horse. The meaning of such a gift is not lost on me. There are few gifts of such value.

I return to the towering rock tree on a vision quest. For four days I fast and sleep in the small tent that I have brought for shelter. On the night of the fourth day my secret vision comes to me, and I am the warrior I was meant to be. The rock tree looms on the night sky, and the Big Dipper rides above it. The stars are again my seven sisters, and I am again the boy who turned into a bear. I am *Tsoai-talee*, Rock Tree Boy, and I will carry that name to the end of the world and beyond. I will keep to the trees and waters, and I will be the singing of the soil. In my truest being I am a keeper of the earth. I will tell the ancient stories and I will sing the holy songs. I belong to the land.

On a late afternoon there came a strange light on the prairie, a copper glow, and it preceded the rising of a red moon. For a long moment it seemed that there were embers on the land, glowing and laying a vague, shimmering smoke on the grass. Away to the east there was in the ground a woman in a beautiful doeskin dress. That is all we know about her, but she belongs to us and to the land. In the pervasive silence she sings a song of the earth. Listen.

N. SCOTT MOMADAY is a poet, Pulitzer Prize–winning novelist, playwright, painter, storyteller, and former professor of English and American literature. Born in Lawton, Oklahoma, in 1934, Navarre Scott Momaday was raised in Indian country in Oklahoma and the Southwest. A member of the Kiowa tribe, his works celebrate Native American culture and the oral tradition. He is a graduate of the University of New Mexico (BA, 1958) and Stanford University (MA, 1960; PhD, 1963), and has held tenured appointments at the University of California, Santa Barbara; Berkeley; and Stanford University, and retired as Regents professor at the University of Arizona. He also served as adjunct professor of Native American Studies at the Institute of American Indian Arts, and as artist-in-residence at St. John's College in Santa Fe, New Mexico. Momaday holds twenty-one honorary doctoral degrees from American and European colleges and universities, and is the recipient of numerous awards and honors in recognition of the work he has done to honor and preserve Native American heritage. These include a National Medal of Arts, the Anisfield-Wolf Lifetime Achievement Award, the Ken Burns American Heritage Prize, and the Dayton Literary Peace Prize Ambassador Richard C. Holbrooke Distinguished Achievement Award. He has also served as Centennial Poet Laureate of the state of Oklahoma and holds the honor of Poet Laureate of the Kiowa tribe. He lives in New Mexico.